THE PHOENIX
UNCOVERED

K11/6

THE PHOENIX
UNCOVERED

The Collins Press

Published in 2005 by
The Collins Press,
West Link Park,
Doughcloyne,
Wilton,
Cork

A Cataloguing-In-Publication data record for this book
is available from the British Library

ISBN: 1-903464-94-3

Cover design and book layout: Niall McCormack
Font: Trade Gothic, 9 point
Printed in Ireland by Betaprint

Contents

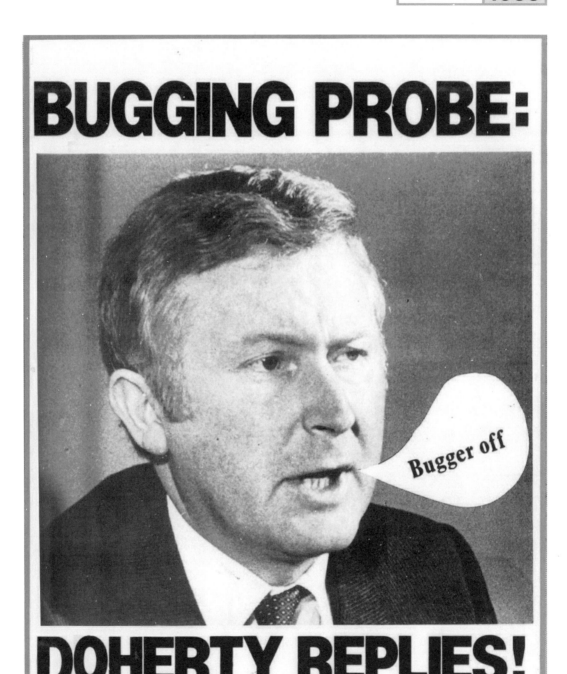

In January 1983, it was revealed that warrants had been signed directing the bugging of the telephones of journalists Bruce Arnold and Geraldine Kennedy. The Minister for Justice at the time of the bugging was Seán Doherty (above).

In April 1983, Vincent Browne (right) launched a new Sunday newspaper, the *Sunday Tribune*. In 1977, Browne had launched the current affairs magazine, *Magill*.

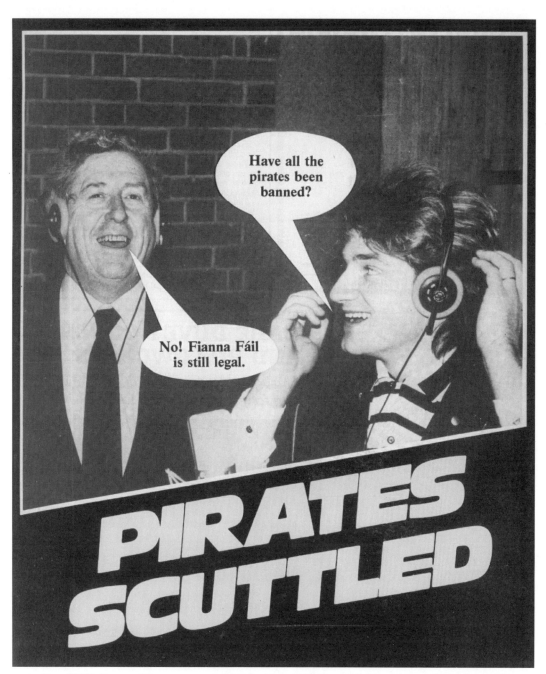

In May 1983, the coalition government led by Garret FitzGerald (left) announced that it would be introducing an Independent Local Broadcasting Bill allowing for the establishment of independent radio. All the existing independent radio stations, known as the pirates, would be banned.

The British Conservative Party, under Margaret Thatcher, celebrated another landslide victory in the General Election of June 1983, which followed the victory of the British Navy against Argentina in the Falklands War the previous year. Meanwhile, Charles Haughey continued to quash opposition within the Fianna Fáil party.

NEW DEAL FOR LOVE~BABIES

On 24 October 1983, the Minister of State at the Department of Justice, Nuala Fennell (pictured left with government colleague, Gemma Hussey), announced that the Government had decided to introduce legislation to reform the law regarding illegitimacy.

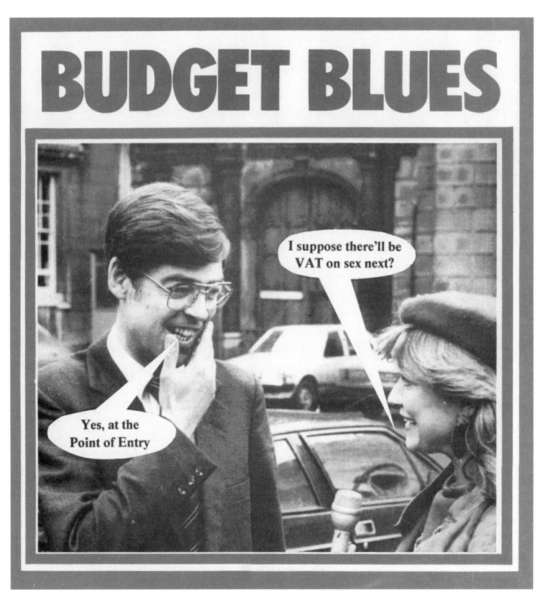

On 25 January 1984, the Minister for Finance, Alan Dukes, gave details of his annual Budget statement.

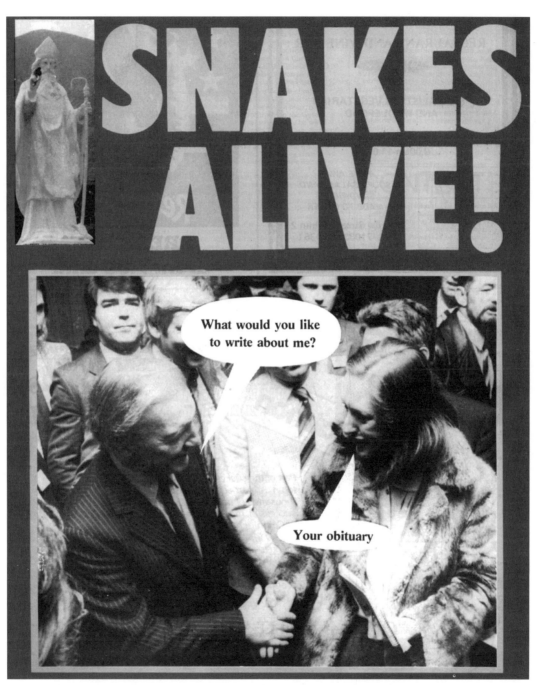

Journalist Geraldine Kennedy (right) had been the victim of telephone bugging under a government led by Charlie Haughey.

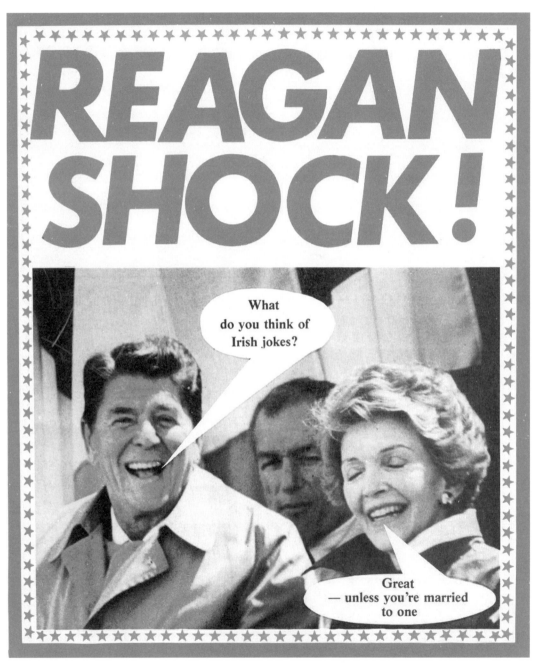

In June 1984, US President Ronald Reagan and his wife, Nancy, visited Ireland. During their official visit, the president spent some time at his ancestral home in Ballyporeen, Co. Tipperary.

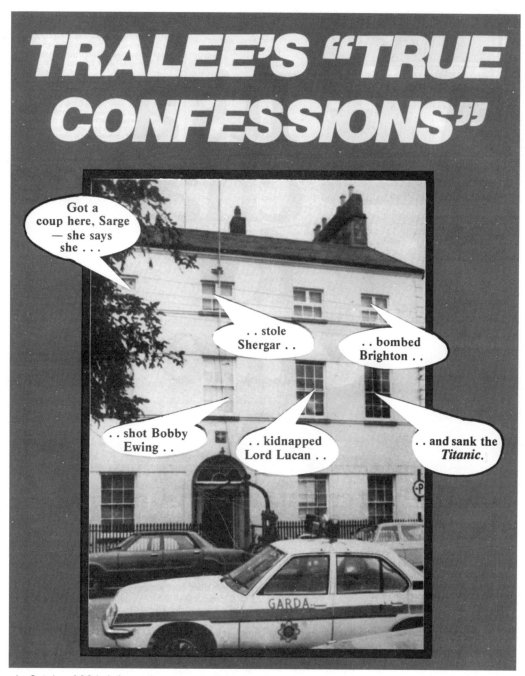

In October 1984, information came to light that Joanne Hayes, an unmarried mother from County Kerry, had confessed to the murder of a baby with whom she had no connection. An independent inquiry was subsequently set up to investigate the manner in which her false statement, and those of members of her family, had been obtained.

SUMMIT- Maggie's message of hope

No Surrender!

In November 1984, a second Anglo-Irish summit was held between the British Prime Minister, Margaret Thatcher, and the Taoiseach, Garret FitzGerald. Following the meeting, Thatcher ruled out the three options proposed in the Report of the New Ireland Forum.

PILL BILL SHOCK

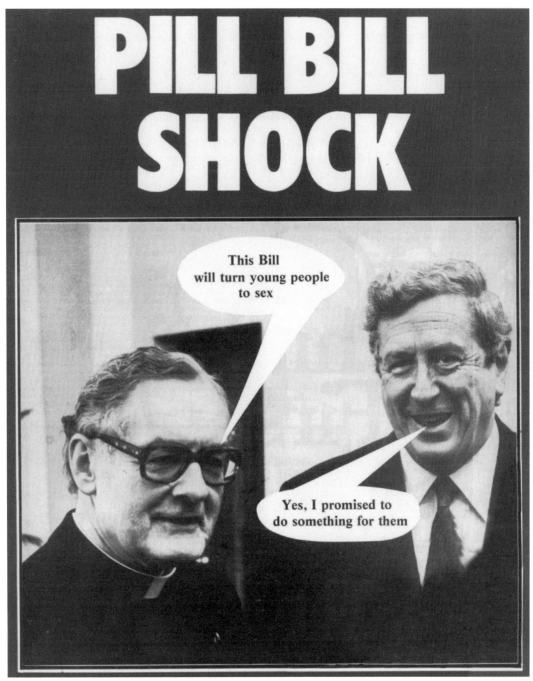

Under strong attack from the Roman Catholic hierarchy (including the Archbishop of Dublin, Kevin McNamara, left), Barry Desmond, Minister for Health in the FitzGerald-led coalition, introduced the (Health) Family Planning Amendment Bill, which was to make contraceptives available to those over the age of eighteen years, without a doctor's prescription.

In August 1985, there were reports from the small town of Mountcollins, County Limerick, that a statue of the Blessed Virgin had been seen to move. In the following months, similar reports emerged from small rural areas all over the country, most famously Ballinspittle in County Cork.

MIRACLE AT KNOCK

In October 1985, Knock Airport opened with an inaugural flight to Rome. The airport was the dream of Monsignor James Horan (right), Parish Priest of Knock.

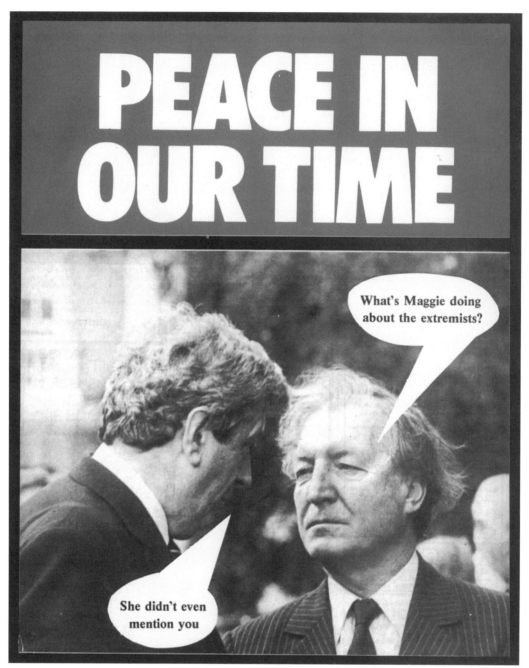

The Anglo-Irish Agreement was signed by British Prime Minister, Margaret Thatcher, and the Taoiseach, Garret FitzGerald (left) on 15 November 1985. In 1970, Charlie Haughey had been dismissed as a cabinet minister for allegedly using government money to import arms for the fledgling IRA.

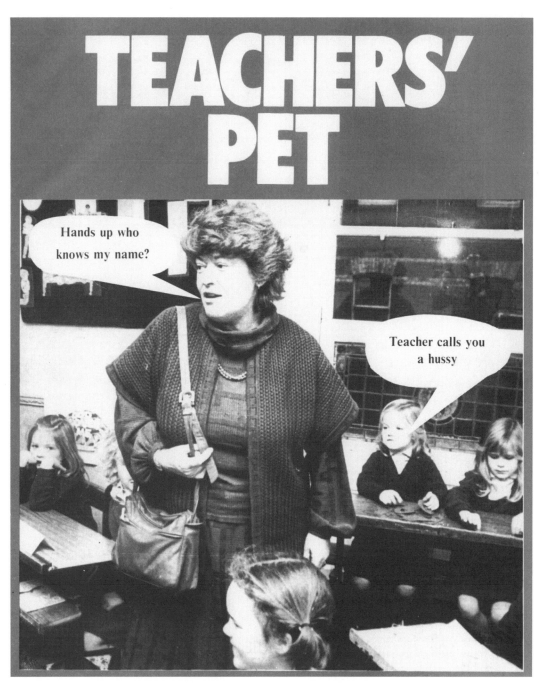

Gemma Hussey was Minister for Education from 1982 to 1986.

In January 1986, Dessie O'Malley founded a new political party — the Progressive Democrats.

SCHOOL CHAOS: COONEY ACTS

March 1986 saw a teachers' pay dispute. Patrick Cooney (right) was Minister for Education at the time.

On 24 April 1986, the Fine Gael-Labour coalition government proposed a referendum on divorce. The constitutional ban on divorce was finally lifted following the referendum of 1995.

Dick Spring (right) was leader of the Labour Party from 1982 to 1997.
He served as Tánaiste in three coalition governments, including that of 1982–87.

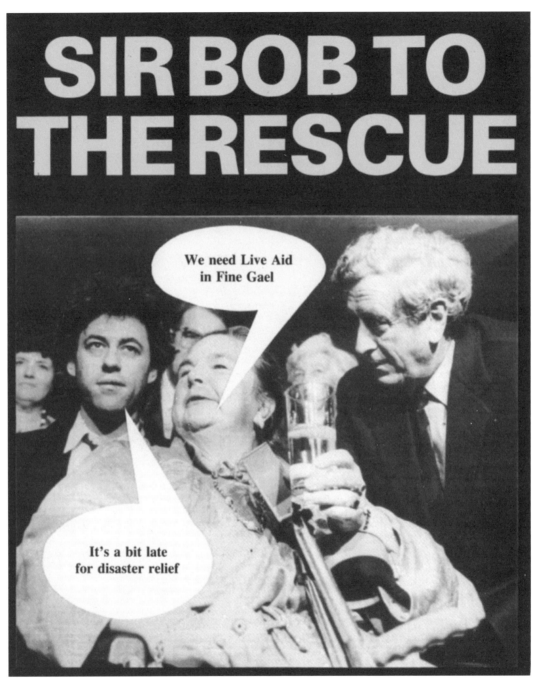

In 1984, British recording artists joined forces in a song, written by Bob Geldof (left) and Midge Ure, the proceeds of which went towards disaster relief in Africa. The following July saw the Live Aid concert. Joan FitzGerald (centre) was the wife of Garret FitzGerald, Fine Gael leader and Taoiseach in 1986, a time when the party was faring badly in the polls.

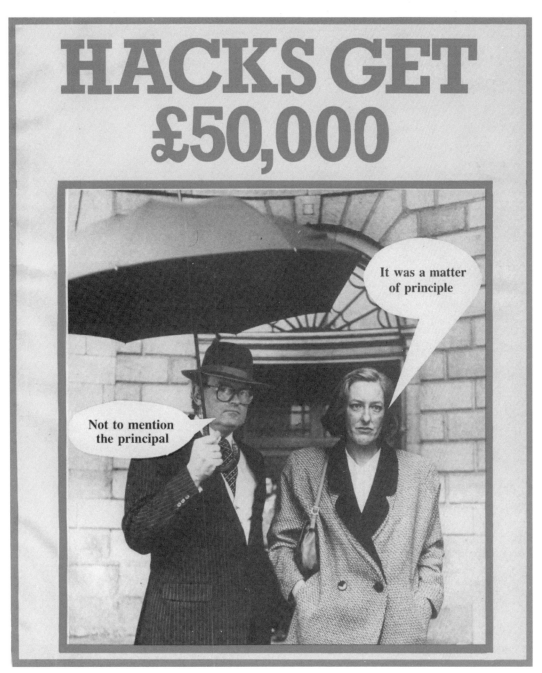

In January 1987, journalists Bruce Arnold and Geraldine Kennedy successfully sued the State for invasion of privacy, arising out of the tapping of their phones.

THE BOSS IS BACK!

In February 1987, Charlie Haughey became Taoiseach in a minority Fianna Fáil government. When Haughey had first come to power in 1979, Garret FitzGerald had used the term 'flawed pedigree' with regard to Haughey's 1970 dismissal from cabinet for allegedly using government money to import arms for the fledgling IRA.

PASSPORT SCANDAL

In 1987, news broke that the Government had been granting Irish citizenship to rich non-nationals in return for investments in the State.

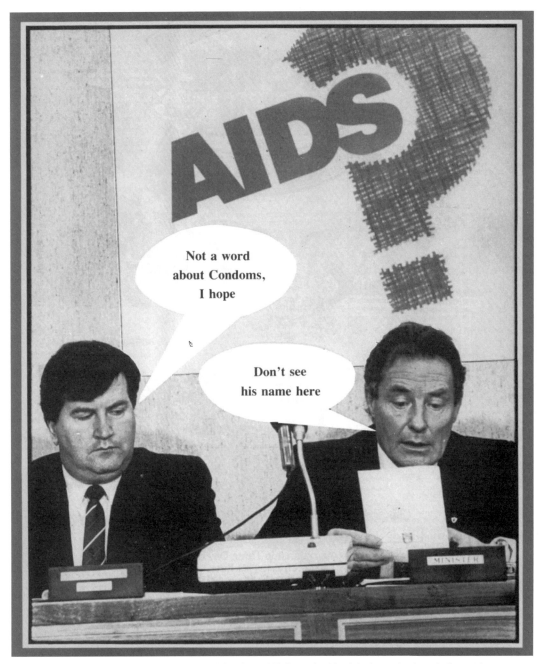

In May 1987, Dr Rory O'Hanlon (right), as Minister for Health, launched an information campaign on AIDS.

In 1987, journalist Geraldine Kennedy was elected to the Dáil as a Progressive Democrat deputy.

In January 1988, Minister for Finance Ray McSharry delivered his Budget.

February 1988 saw the launch of Comic Relief's first Red Nose Day.

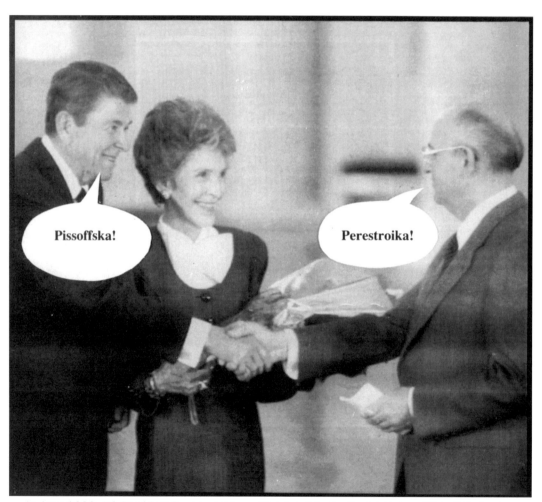

In June 1988, US President Reagan paid an official visit to the Soviet Union. Mikhail Gorbachev (right) had recently become President and was beginning his reforms which included Perestroika (restructuring of the economy).

Jack Charlton (centre) was appointed manager of the Republic of Ireland soccer team in 1986.
Two years later, the team qualified for the European Championship in Stuttgart. On 15 June 1988,
Ireland beat England, 1-0, with a goal scored by Frank Stapleton (left).

Broadcaster Gay Byrne presented the annual Rose of Tralee competition for seventeen years.
He stepped down in 1994.

According to the terms of the Radio and Television Act, 1988, all unlicensed radio stations had
to be off the air by the end of December of that year. Ray Burke (left) was
Minister for Communications at the time.

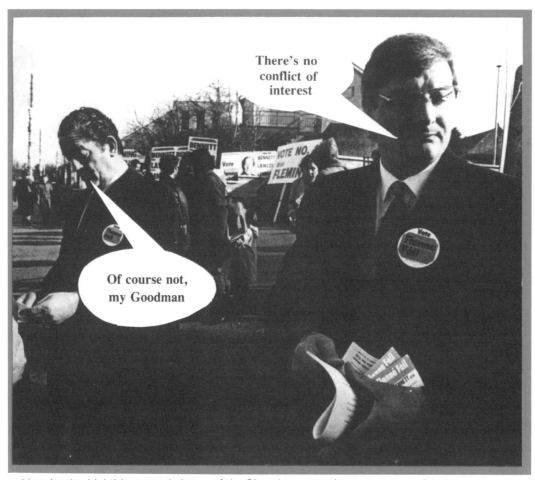

Liam Lawlor (right) became chairman of the Oireachtas committee on commercial state-sponsored bodies, in 1987. He resigned this office two years later because of his close ties with a company run by Larry Goodman.

In 1989, under Mikhail Gorbachev (left), Russia held its first openly contested elections for parliament. The following year, the Communist Party voted to end the one-party system. Fianna Fáil has been in Government for almost two-thirds of the life of this State.

On 7 May 1989, Frank Sinatra and Liza Minnelli (above), together with Sammy Davis Jnr, performed at Lansdowne Road, Dublin.

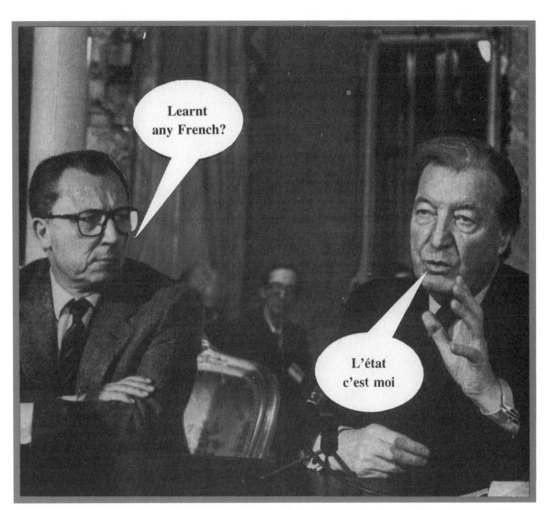

On 8 and 9 December 1989, the Taoiseach, Charlie Haughey, attended the European Council in Strasbourg. Haughey was Taoiseach in 1979-81, 1982, and 1987-92.

During the 1990 soccer World Cup, Ireland manager Jack Charlton (left) had several very public arguments with commentator Eamon Dunphy, regarding tactics. In a country overtaken by World Cup fever, Dunphy's criticisms were greeted with much hostility.

At the time of the summer recess, Dessie O'Malley (left) was leader of the Progressive Democrats, Dick Spring (below right) was leader of the Labour Party and Alan Dukes (pictured behind Spring) was leader of Fine Gael. Throughout the 1980s, Fine Gael had seen a decline in support.

During the 1990 Presidential Election campaign, a tape recording by a university research student contradicted Fianna Fáil candidate Brian Lenihan's (left) statement regarding his actions in attempting to prevent a dissolution of the Dáil in 1981. Seán Doherty (centre) was the Minister for Justice at the time of the 1982 tapping of journalists' phones.

Following his defeat in the 1990 Presidential Election campaign, Brian Lenihan was sacked from Charlie Haughey's cabinet. In the course of the campaign, Lenihan had become embroiled in a controversy regarding whether or not he had attempted to intervene with President Hillery to prevent a dissolution of the Dáil in 1981.

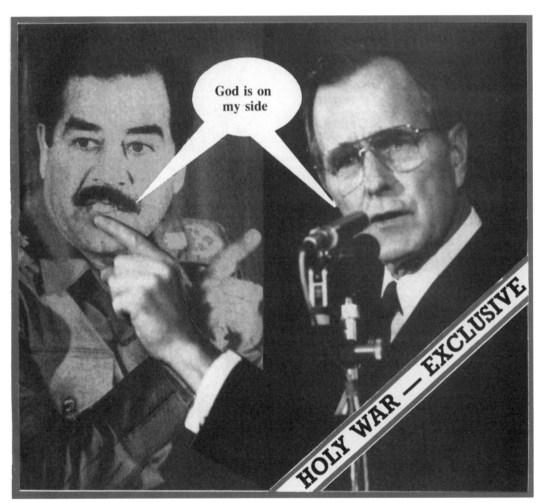

In August 1990, Iraqi forces invaded Kuwait. Saddam Hussein refused to withdraw his troops, and, on 17 January 1991, led by US President George Bush, the Gulf War began.

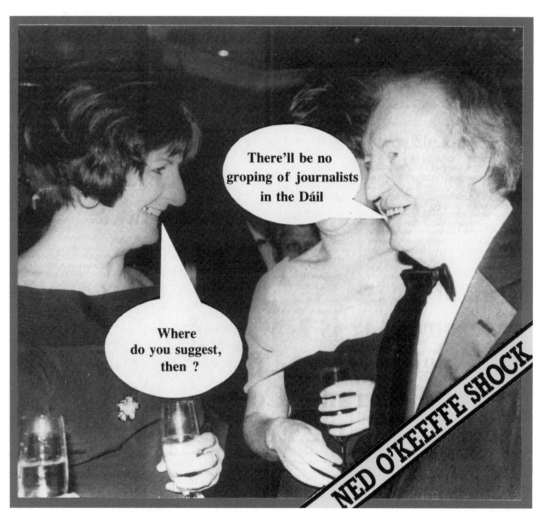

In 1991, Deputy Ned O'Keeffe was involved in an incident in the Dáil bar with a female journalist, for which he later apologised in the Dáil. For many years, Charles Haughey (right) had an extra-marital relationship with social diarist Terry Keane (left).

Throughout autumn 1991, there was speculation that the Minister for Finance, Albert Reynolds (right), might have enough support to launch a leadership challenge to Charlie Haughey.

At the end of September 1991, opposition leader John Bruton demanded that Dermot Desmond (left) resign as chairman of Aer Rianta. Bruton claimed that Desmond's company, NCB, had attempted to pass confidential information about an Aer Lingus subsidiary, Irish Helicopters, to its rival, Celtic Helicopters, owned by the Taoiseach's son.

In November 1991, Albert Reynolds' challenge to the Haughey leadership was defeated
by 55 votes to 22. Reynolds and two of his supporters, Pádraig Flynn (left) and
Máire Geoghegan Quinn (centre), were sacked from the cabinet.

Peter Brooke (right) was forced to resign as Secretary of State for Northern Ireland following an appearance on the *Late Late Show*, the day after an IRA bombing, when he sang the song, 'Clementine'. Gerard Collins (left) was Minister for Foreign Affairs at the time.

Following his success in the World Championship of 1985, boxer Barry McGuigan had been loud in his gratitude to his manager, Barney Eastwood (left). However, in 1987, McGuigan and Eastwood were involved in a much publicised break-up, and the relationship ended in court.

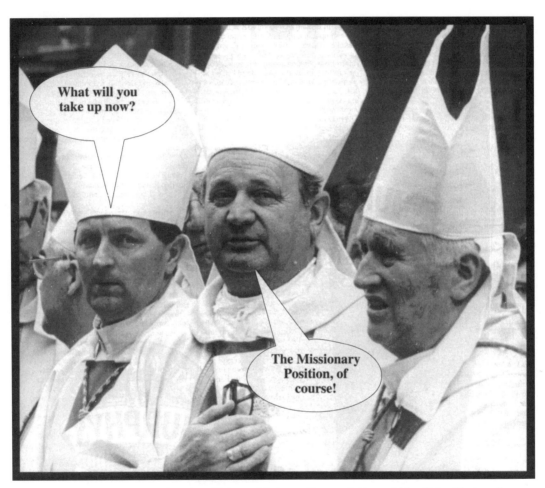

Eamonn Casey (centre) resigned as Bishop of Galway after revelations of his affair with American divorcée Annie Murphy, with whom he had had a son. He went to work in the South American missions in Ecuador.

Early in 1992, after Charles Haughey was forced to resign as both Taoiseach and leader of
Fianna Fáil, Albert Reynolds (right) was elected by the party as his replacement.
Millionaire businessman Michael Smurfit (left) had made several donations to the
Fianna Fáil party during Haughey's time as leader.

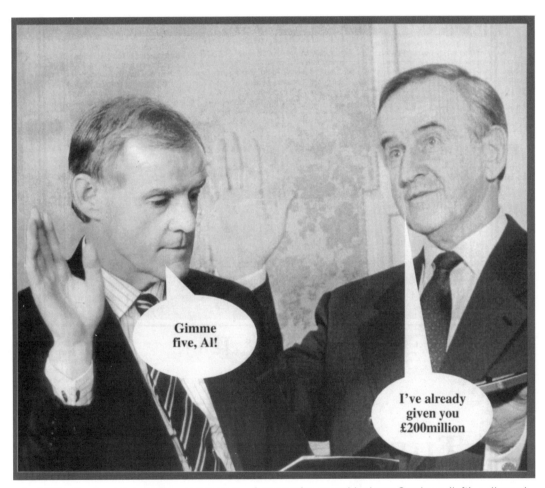

In 1992, Goodman International, the group of companies owned by Larry Goodman (left), collapsed with debts of over IR£500 million. The group was later the subject of a major tribunal set up to investigate fraud, tax evasion and the use of political influence to secure State-backed export credit insurance.

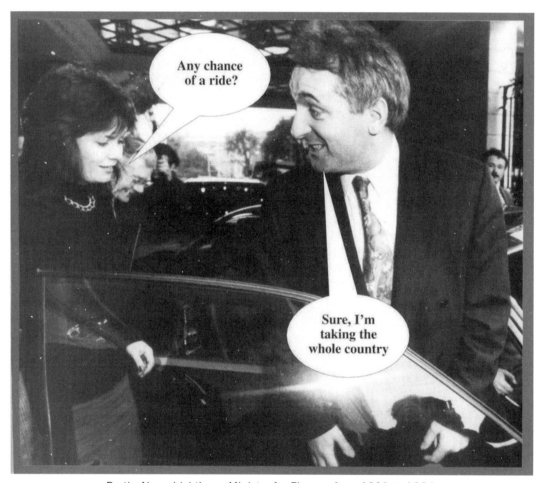

Bertie Ahern (right) was Minister for Finance from 1991 to 1994.

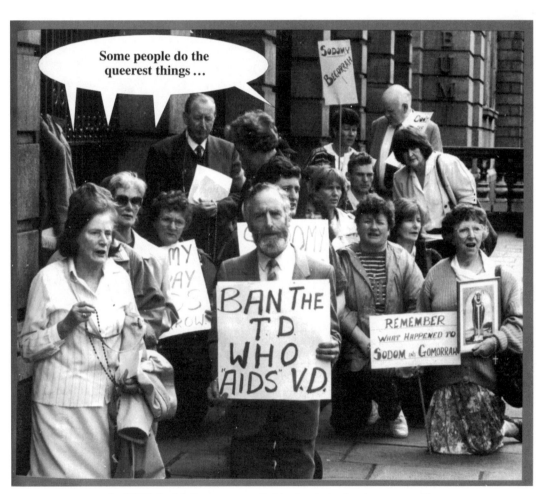

In 1993, legislation was enacted to decriminalise homosexuality.

In 1989, U2's Adam Clayton (right) appeared in court charged with possessing 19g of marijuana. Michael D. Higgins (left) was Minister for Arts, Culture and the Gaeltacht from 1993 to 1997.

Tony O'Reilly (right) is Chairman and Chief Executive Officer of the H.J. Heinz Company, Chairman of Independent Newspapers Plc, and Chairman of Fitzwilton Plc, the majority shareholder in Waterford Wedgwood. He is also the principal shareholder in Arcon International Resources Plc, and a Director of the New York Stock Exchange.

Former Dunnes Stores chairman Ben Dunne (left) began High Court proceedings against his siblings (including Margaret Heffernan, right) after he was ousted from the family firm. In February 1992, Ben Dunne had been charged in Florida with possession of cocaine.

In January 1994, Minister for Finance Bertie Ahern (left) introduced his annual Budget.
Vincent Browne (right) was editor of the *Sunday Tribune* until that month.

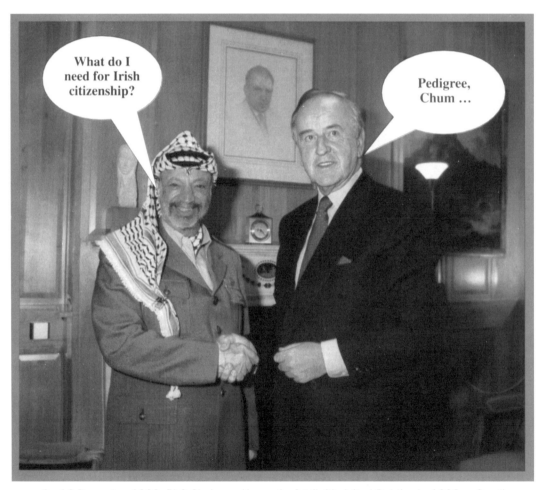

On 16 December 1993, PLO Chairman Yasser Arafat (left) visited Dublin. In 1992, a Saudi businessman had received an Irish passport after investing £1 million in the family pet-food business of then Taoiseach, Albert Reynolds (right). Reynolds denied he had any knowledge of the investment in the company, which was run by his son.

In summer 1994, Albert Reynolds was Taoiseach in a Fianna Fáil-Labour coalition,
while Fine Gael leader John Bruton (left) was leader of the opposition.

On 26 August 1994, the IRA announcement of a ceasefire was just five days away. SDLP leader John Hume had been in discussion with Sinn Féin President Gerry Adams since the previous year, in an effort to bring this about.

Attorney General, Harry Whelehan (right) was slow to act to ensure the extradition of Fr Brendan Smyth, to face child sex-abuse charges in Northern Ireland. Taoiseach Albert Reynolds' decision to appoint Whelehan as President of the High Court led to the collapse of Reynolds' coalition government.

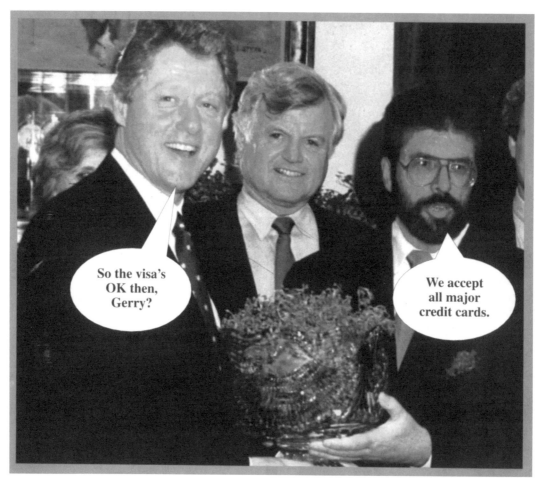

In 1995, with the IRA ceasefire still in place, US President Bill Clinton (left) agreed to give Gerry Adams a visa to travel to the US to fundraise for Sinn Féin. It was Senator Ted Kennedy (centre) who persuaded Clinton to grant the visa.

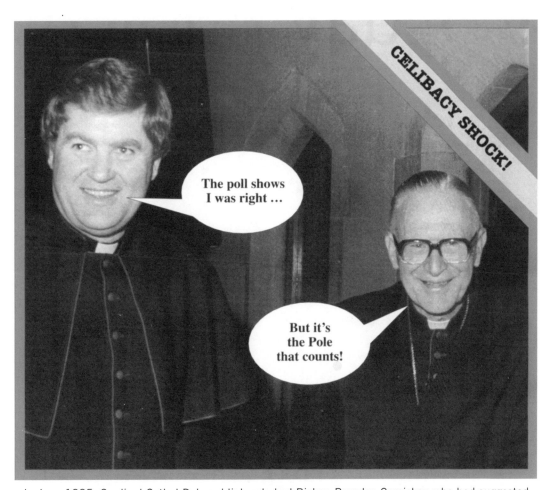

In June 1995, Cardinal Cathal Daly publicly rebuked Bishop Brendan Comiskey, who had suggested
the need for a more open debate on the question of priestly celibacy.
Bishop Comiskey was further admonished by the Vatican.

In 1995, David Trimble (right) appeared at the annual Drumcree Orange march, hand-in-hand with Ian Paisley, after they won the stand-off with the nationalist community of the Garvaghy Road. On his election the following September as UUP leader, he vowed not to enter into peace talks with Sinn Féin.

In September 1995, the Provisional IRA made its first statement on decommissioning, in which it said that there was 'no possibility of disarmament except as part of a negotiated settlement'.

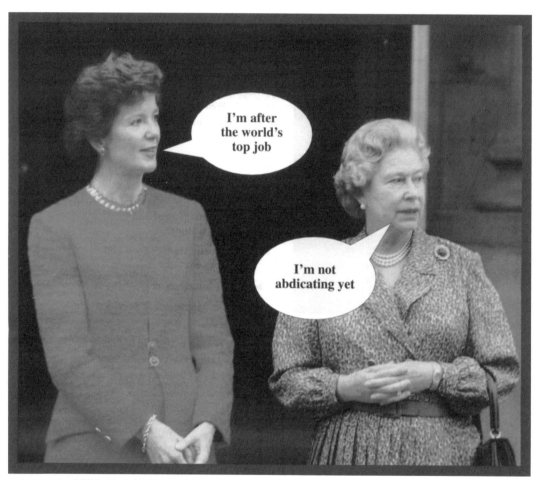

In 1995, Mary Robinson became the first Irish President to visit Queen Elizabeth at Buckingham Palace. Already, speculation was beginning regarding what she would do at the end of her Presidential term of office.

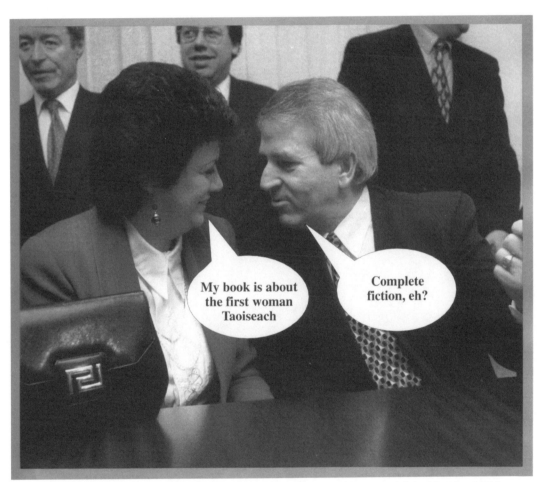

The Green Diamond, a novel by Máire Geoghegan Quinn (left), was published in May 1996.
At the time, both she and Charlie McCreevy (right) were on Bertie Ahern's opposition front bench.

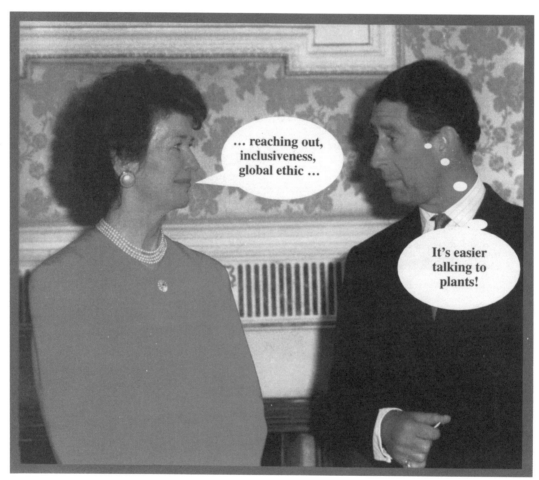

During his 1995 visit to Ireland, the Prince of Wales (right) visited President Mary Robinson at Áras an Uachtaráin.

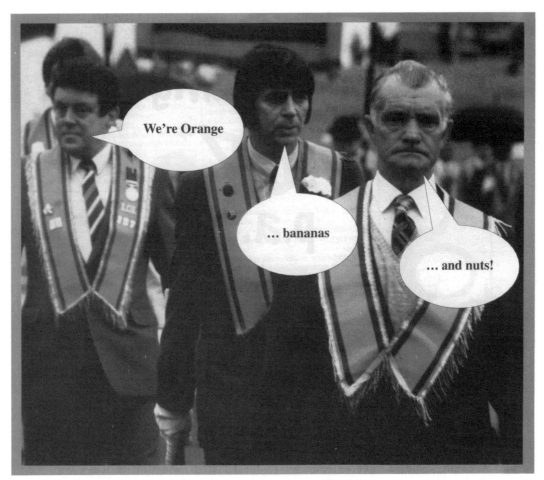

On 7 July 1996, the RUC prevented a march by Orangemen returning from Drumcree church via the nationalist Garvaghy Road. Following widespread protest in the unionist community, and rioting in loyalist areas, the RUC Chief Constable reversed his decision and the march was allowed to proceed the following Thursday.

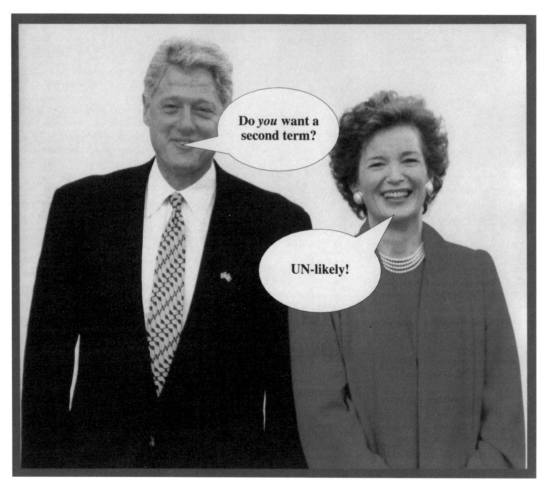

In November 1996, US President Bill Clinton was elected to a second term of office.
Mary Robinson had been elected President of Ireland in 1990. Instead of putting herself forward
for re-election in 1997, she became UN High Commissioner for Human Rights.

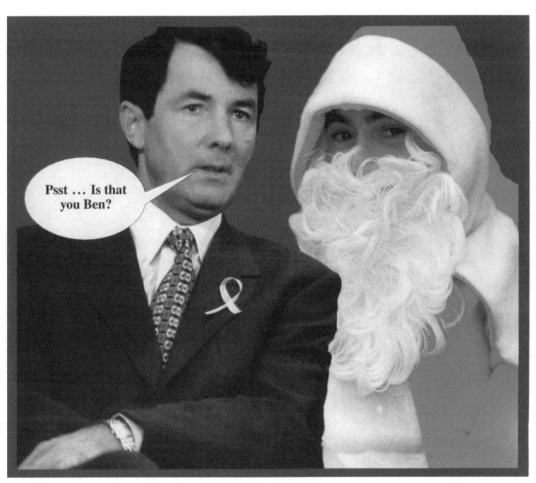

Fine Gael's Michael Lowry (left) accepted large monetary payments from Ben Dunne. Both Lowry and Charlie Haughey were the subject of investigation in the McCracken Report, published in August 1997.

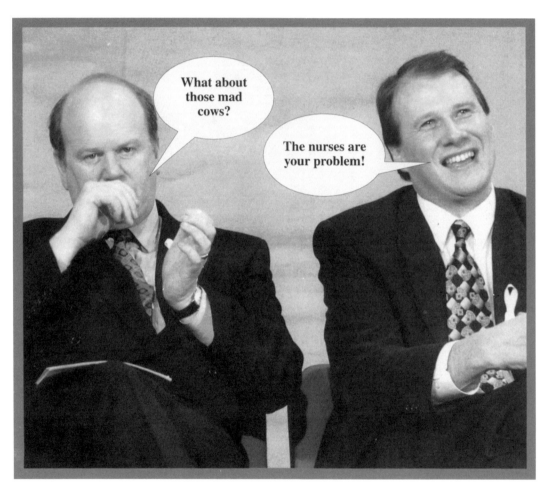

A further two cases of BSE were reported at the end of 1996, bringing the total for the year to 73.
Fine Gael's Ivan Yates (right) was Minister for Agriculture, Food and Forestry at the time.
Meanwhile, the Minister for Health, Michael Noonan (left) was working to avert strike action by nurses.

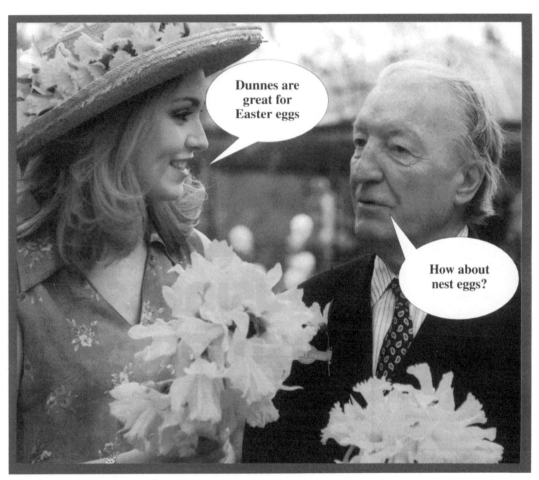

By 1997, it was known that former Taoiseach Charlie Haughey (right) had accepted large monetary gifts from Ben Dunne, who at the time was chairman of Dunnes Stores.

In May 1997, the Labour Party, led by Tony Blair (left) swept to power in the British General Election.
Meanwhile, John Bruton (right) was leading a coalition government in which,
through force of numbers, the Irish Labour Party had considerable power.

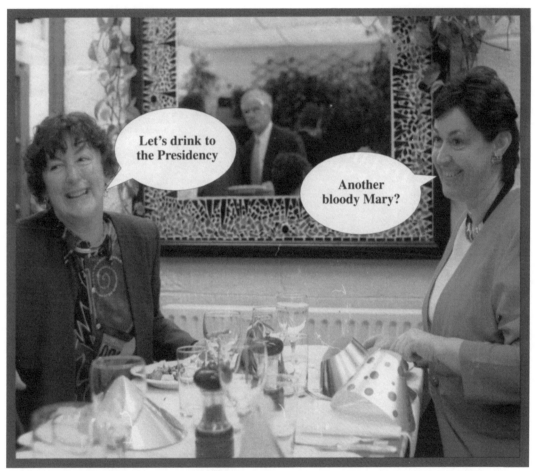

In August 1997, Mary Banotti (left) was announced as the Fine Gael candidate in the forthcoming Presidential Election to replace outgoing President Mary Robinson. The Fianna Fáil candidate was Mary McAleese. Banotti's sister, Nora Owen (right) was Minister for Justice, 1994–97, and deputy leader of Fine Gael.

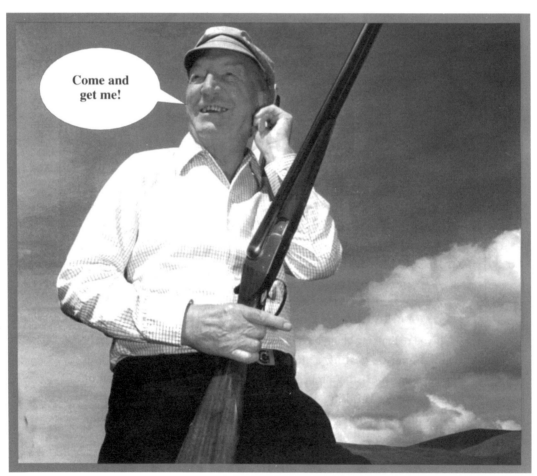

In August 1997, the Report of the Tribunal of Inquiry into Dunnes Stores' payments to politicians (the McCracken Report) was published. The Report concluded that payments had been made by Ben Dunne to former Taoiseach Charlie Haughey and former Minister Michael Lowry.

In early January 1998, British Foreign Secretary Robin Cook announced his intention to divorce his estranged wife and marry his secretary, with whom he had been having an affair. Meanwhile, Celia Larkin (left) continued to partner the Taoiseach, Bertie Ahern, for official functions, although Ahern had never divorced his wife, Miriam.

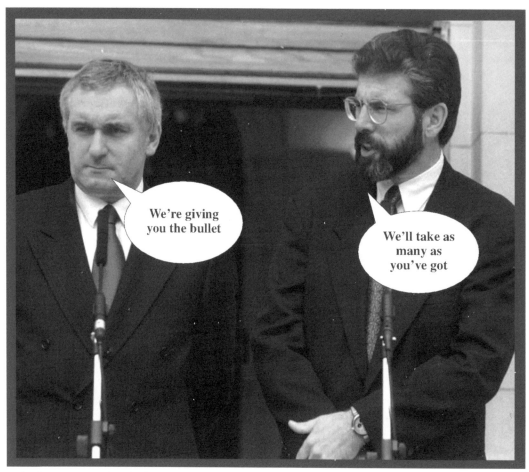

In the run up to the signing of the Good Friday Agreement (30 April 1998), the Irish Government exerted pressure on the Republican side to reach a compromise.

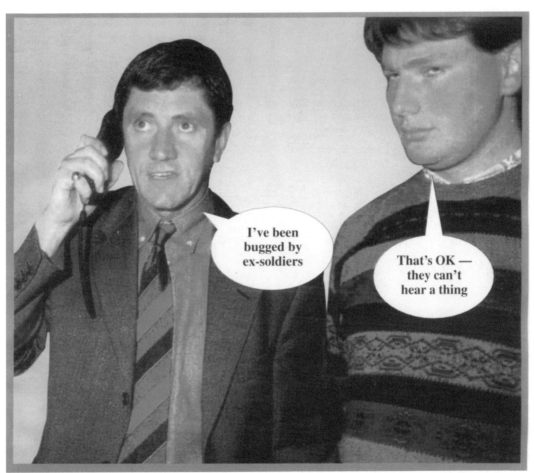

In April 1998, there were reports of possible interference with the telephones of two RTÉ reporters, George Lee and Charlie Bird (left). Meanwhile, in 1998 alone, 54 claims a week were made by members and former members of the defence forces, in respect of hearing loss.

In May 1998, the Ulster Unionist Party, under the leadership of David Trimble (right), launched its campaign for a 'Yes' vote in the referendum on the Good Friday Agreement.

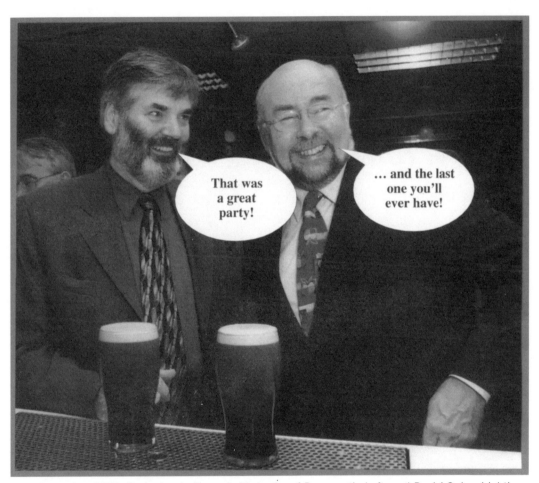

In December 1998, Proinsias de Rossa (left), leader of Democratic Left, and Ruairí Quinn (right), leader of the Labour Party, announced that the parties had decided to merge.

In January 1999, the future of Pádraig Flynn as Ireland's European Commissioner came into question following his appearance on the *Late Late Show*. Flynn was questioned on the show about an alleged payment of £50,000 by property developer Tom Gilmartin.

In April 1999, singer Sinead O'Connor (left) was ordained a Catholic priest by Bishop Michael Cox, leader of the breakaway Latin Tridentine Church. She donated IR£150,000 to Cox.

In the European elections of 1999, Dana Rosemary Scallon (right) contested the Connacht-Ulster constituency as an Independent; she took the third seat. In 1970, she had won the Eurovision Song Contest with the ballad 'All Kinds of Everything'.

In summer 1999, controversy arose about Tánaiste Mary Harney's frequent use of the government jet.

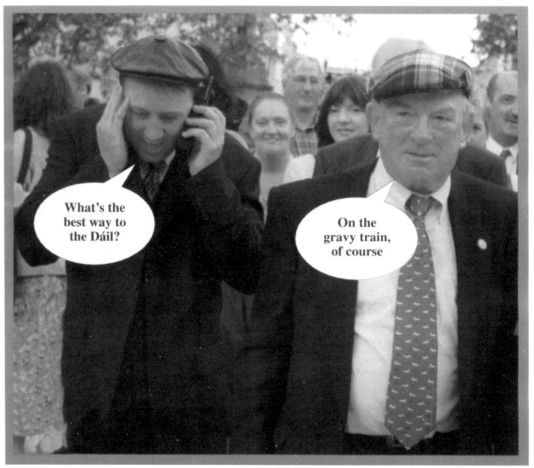

Following the 1997 General Election, four Independent deputies, including Kerry TD
Jackie Healy Rae (right), held the balance of power, allowing them to use their Dáil vote
as a bargaining tool to have funds directed to their constituency areas.

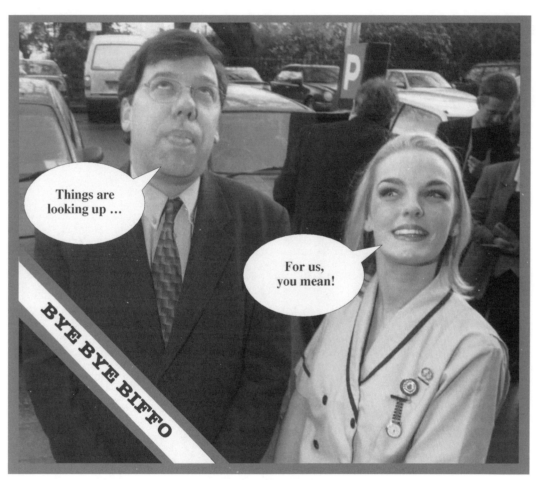

Brian Cowen was appointed Minister for Foreign Affairs in January 2000. He had been Minister for Health and Children since June 1997.

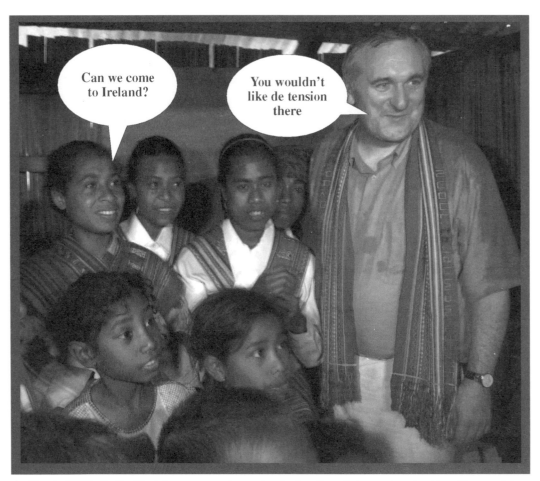

In March 2000, Bertie Ahern's government was developing its policies on immigration. The provisions of the Illegal Immigrants (Trafficking) Act, 2000, which was passed later in the year, allowed for the detention of asylum seekers.

In evidence to the Flood Tribunal in April 2000, lobbyist Frank Dunlop (right) said that IR£112,000 had been paid to members of Dublin County Council at the time of the Quarryvale re-zoning.

In July 2000, it was announced that broadcaster Gay Byrne (left) would present the Irish version of the popular TV quiz show, *Who Wants to Be a Millionaire?*

Throughout 2000, Eircom shares continued to fall in value. The shares had been launched amid much hype in July 1999.

In 2001, a High Court jury found that Mayo TD Beverly Cooper-Flynn (left) was not libelled by broadcasts alleging that she had advised people to invest in offshore funds to evade taxes. The ruling left her with legal bills in excess of €2 million. Two years earlier, her father, EU Commissioner Pádraig Flynn (right), had aroused controversy when justifying his income by referring to the cost of the upkeep of his three houses.

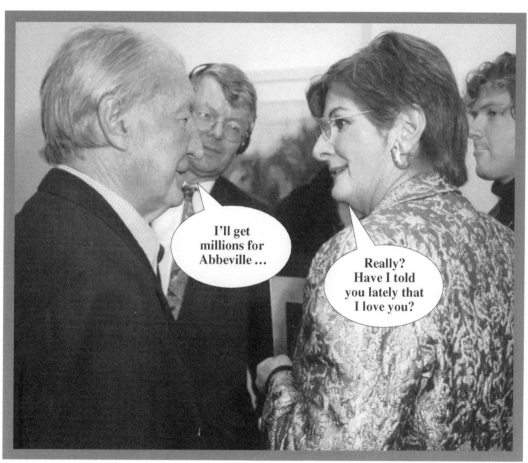

In 1999, gossip columnist Terry Keane (right) appeared on the Late Late Show and revealed details of her long-term affair with former Taoiseach Charlie Haughey. In August 2001, Haughey denied reports that he had sold his Abbeville mansion and its 270-acre estate for IR£30 million.

Following the attacks on New York and Washington in September 2001, US President George Bush (left) sought universal support for his plans to bomb Afghanistan.

US President George W. Bush was widely condemned in Ireland throughout the bombing campaign in Afghanistan.

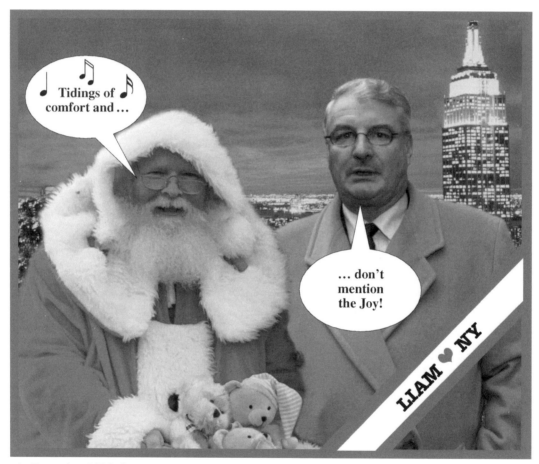

In December 2001, it was reported that Liam Lawlor would be spending Christmas in New York with his son and daughter-in-law. Lawlor had been sentenced by the High Court to a week in Mountjoy Prison for his failure to comply with orders to provide the Flood Tribunal with financial documents. The sentence was postponed until his return from New York.

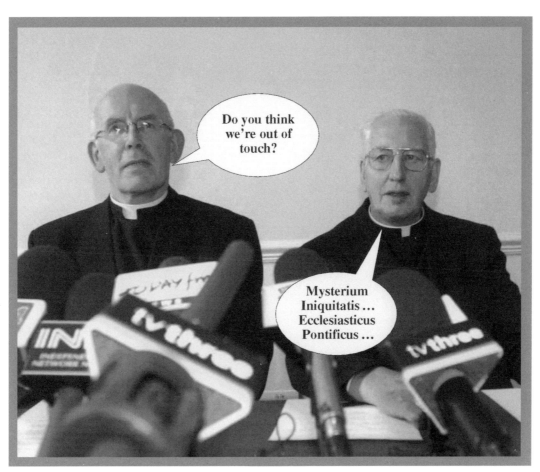

In April 2002, the Catholic hierarchy held a day-long meeting in Maynooth to discuss clerical child sex abuse. Following the meeting, Archbishops Sean Brady (left) and Desmond Connell (right), spoke at a press conference.

Following the General Election in May 2002, Michael McDowell (left) was appointed by Taoiseach Bertie Ahern as Minister for Justice, Equality and Law Reform. Earlier in the month, McDowell had referred to the so-called 'Bertie Bowl' sports stadium as a 'Ceausescu-era Olympic Stadium'.

Throughout the summer of 2002, rumours were rife about problems in the relationship between Taoiseach Bertie Ahern and his partner, Celia Larkin (right).

August 2002 saw the publication of footballer Roy Keane's autobiography, ghost-written by journalist Eamon Dunphy (right).

In August 2002, Dublin City Council erected a new traffic management signage system. Following criticism, however, the signs were all taken down and a new directional signage system was introduced the following year.

The Taoiseach's daughter, Cecilia Ahern (left), secured a large advance for her novel, *PS. I Love You.*

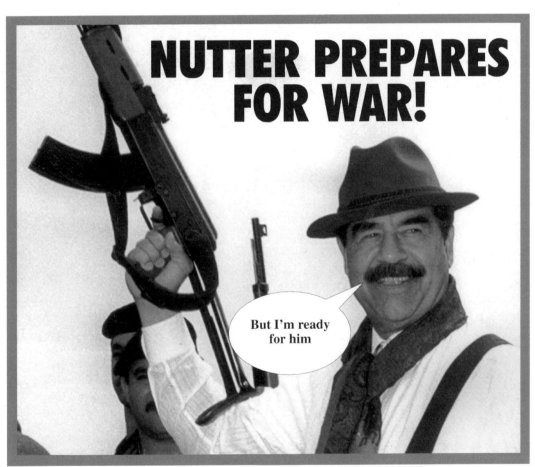

In the early months of 2003, US President George Bush was preparing for war with Iraq.

In February 2003, the Iraqi war was just a month away.

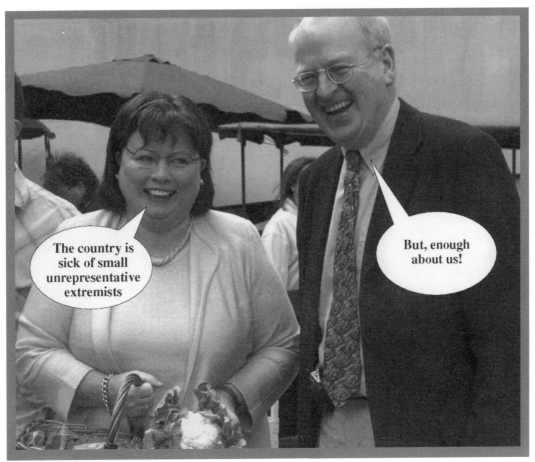

The Progressive Democrats, under leader Mary Harney (left), won eight Dáil seats in the 2002 General Election.

The Minister for Finance, Charlie McCreevy (left), delivered his
2003 Budget speech on 4 December 2003.

In February 2004, the Minister for the Environment, Martin Cullen, launched an advertising campaign to explain the new electronic voting which was to be used throughout the country in June's local and European elections.

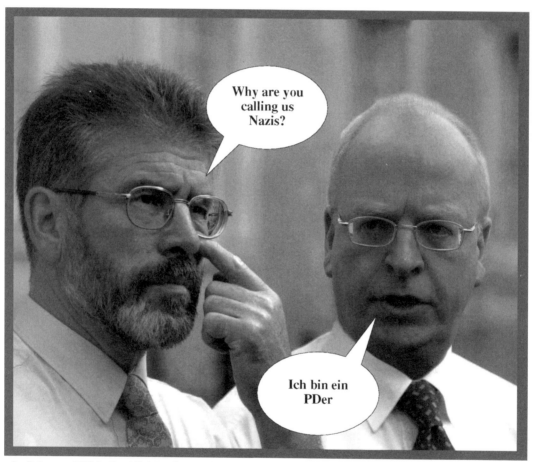

In February 2004, the Minister for Justice, Progressive Democrat Michael McDowell (right), accused Sinn Féin leaders Gerry Adams (left) and Martin McGuinness of membership of the IRA army council. He also compared the republican newspaper, *Daily Ireland*, with a Nazi propaganda sheet of the 1930s.

In spring 2004, the country faced a referendum on citizenship rights. Meanwhile, polls showed Sinn Féin with 10 per cent of the vote, while the Progressive Democrats, party of Minister for Justice Michael McDowell and Liz O'Donnell (right), had only 4 per cent.

Admired among fellow leaders for his handling of the Irish EU presidency in the first half of 2004,
Bertie Ahern was mentioned as a possible candidate for the position of Commission President.
Brian Cowen (right) was seen as the most likely person to succeed him as Fianna Fáil leader and Taoiseach.

In December 2004, DUP leader Ian Paisley (right) was infuriated when Bertie Ahern suggested that the Government's position on decommissioning was no longer workable. In a nine-minute telephone conversation with Paisley, the Taoiseach apologised for his gaffe.

In February 2005, the Minister for Justice, Michael McDowell, claimed that Sinn Féin's
Martin McGuinness, Gerry Adams and Martin Ferris were members of the IRA army council.
The Taoiseach, Bertie Ahern, stated that he did not know who the members of the army council were.

After several years of pressure to build a second terminal at Dublin Airport, Bertie Ahern's coalition government finally announced in May 2005 that the new terminal would be developed by the state-appointed Dublin Airport Authority. The Tánaiste and PD leader, in common with Ryanair Chief Executive Michael O'Leary (left), had publicly favoured a terminal developed and run by private investors.

Following France's rejection of the EU constitution, on 29 May, President Jacques Chirac (left) promised major cabinet changes, and Jean-Pierre Raffarin tendered his resignation as Prime Minister.

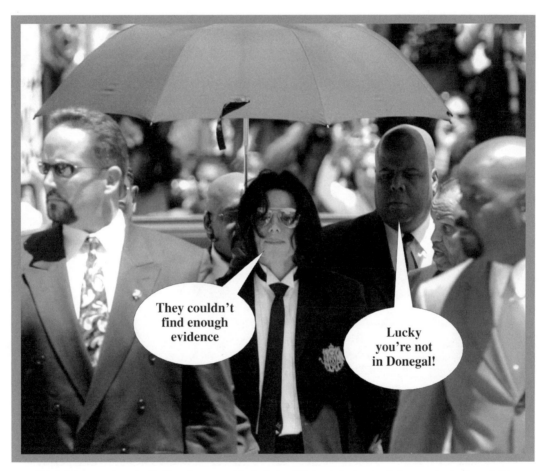

On 14 June, a jury in California exonerated singer Michael Jackson of charges including child molestation. Meanwhile in Ireland, the Morris Tribunal heard evidence that gardaí in Donegal had been involved in corruption, including attempts to frame Frank McBrearty Jr and Mark McConnell for the murder of cattle dealer Richie Barron.

As Britain prepared to host a summit of G8 leaders in Gleneagles in Scotland, in July 2005,
U2's Bono was involved with Bob Geldof in organising Live8 concerts to publicise
the plight of African countries and force the G8 leaders to increase aid
and cancel the debts of Third World nations.